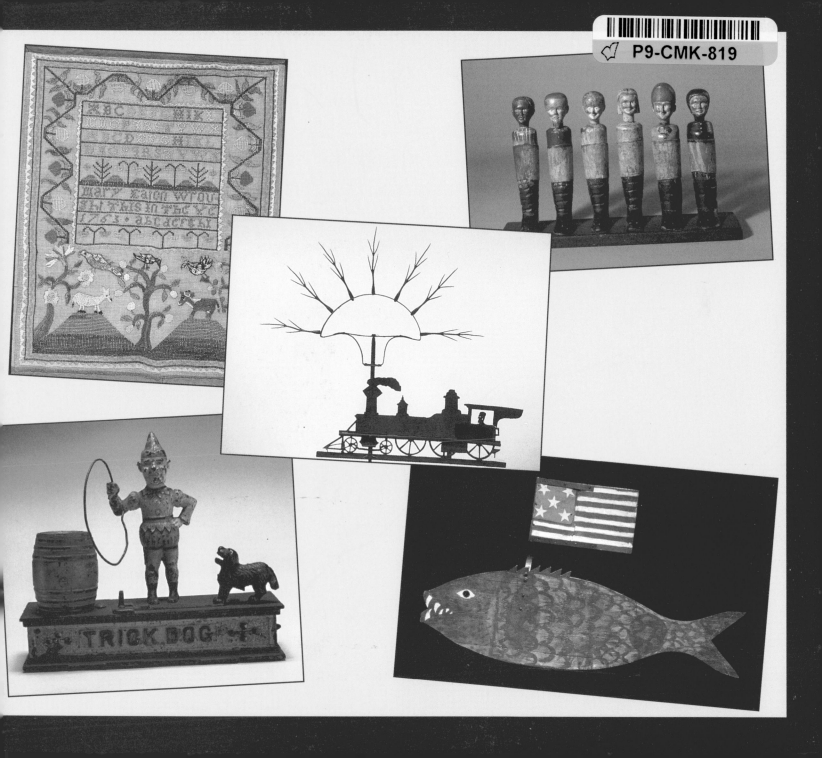

ELECTRA
to the Rescue

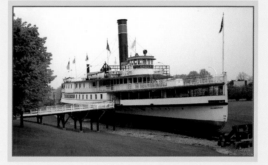

SAVING A STEAMBOAT
and the Story of
SHELBURNE MUSEUM

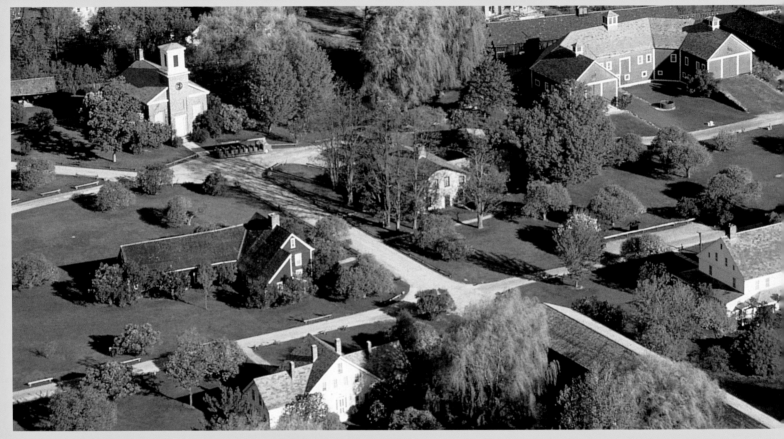

Shelburne Museum in Shelburne, Vermont today.

ELECTRA
to the Rescue

SAVING A STEAMBOAT
and the Story of
SHELBURNE MUSEUM

Valerie Biebuyck

AFTERWORD BY ELLIOT BOSTWICK DAVIS

DAVID R. GODINE
Publisher · Boston

First published in 2008 by
DAVID R. GODINE · *Publisher*
Post Office Box 450
Jaffrey, New Hampshire 03452
www.godine.com

LIBRARY OF CONGRESS CATALOGING-IN-PUBLICATION DATA
Biebuyck, Valerie.
Electra to the Rescue: Saving a Steamboat and the Story of Shelburne Museum / by Valerie Biebuyck ; afterword by Elliot Bostwick Davis.— 1st ed.
p. cm.
ISBN-10 1-56792-308-9
1. Shelburne Museum. 2. Americana. 3. Folk art—United States. 4. Webb, Electra Havemeyer. 5. Collectors and collecting—Vermont—Shelburne—Biography. I. Title.
F59.S49B54 2006
974.3'17—DC22
2005037898

FIRST EDITION
Printed in China by Everbest Printing Company

For Daniel and Aurelia

For information about Shelburne Museum and its collections, please visit their Web site, www.shelburnemuseum.org.

A NOTE ON SOURCES
Quotes in *Electra to the Rescue* are drawn from material in the archives of Shelburne Museum.

ILLUSTRATIONS ON THESE PAGES
PAGE 1: The steamboat *Ticonderoga*, Champlain Transportation Company, Shelburne, Vermont, 1905–1906 (see pages 30 – 33).

PAGE 2: Aerial view of Shelburne Museum in Shelburne, Vermont.

PAGE 3: Electra Havemeyer Webb at age nineteen, c. 1908; *Carousel figure* (detail), Daniel Muller for the Gustav Dentzel Carousel Company, Philadelphia, Pennsylvania, c. 1902 (see page 26); *Haskins Crazy Quilt* (detail), Delphia Ann Noice Haskins, Rochester, Vermont, 1870–1880 (see page 14).

OPPOSITE: Electra Havemeyer Webb riding the carousel at the Champlain Valley Fair, c. 1947. Shortly after establishing the Museum, Electra had a dream about a carousel: "A really wonderful dream – music playing, my husband, my children, and all the grandchildren riding the merry-go-round animals, laughing and reaching for the gold ring. Laughter filled my soul and on waking, I felt refreshed and full of life and ambition and was convinced the carousel should become a part of Shelburne Museum."

ENDPAPERS, clockwise from top left: *TOTE*, weathervane, maker unknown, nineteenth century, painted sheet iron (see page 17). *Velocipede*, maker unknown, early 1900s (see page 43). *Spinning Woman*, whirligig, maker unknown, late nineteenth century, carved and painted wood (see page 15). *Sampler*, Mary Eaton, 1763, silk embroidered on linen (see page 39). *Locomotive*, weather vane, maker unknown, mid-nineteenth century, sheet zinc, brass, and iron (see page 48). *Nine pins*, maker unknown, nineteenth century, carved and painted wood (see page 44). *Fish with flag*, trade sign fragment, maker unknown, mid-nineteenth century, painted wood and sheet iron (see page 18). *Trick Dog Jumps through Hoop*, mechanical bank, 1888, cast iron with paint (see page 35). *Miniature lion circus wagon* from the Roy Arnold Circus Parade, c. 1925–1955, carved and painted wood, leather, and metals (see page 27). *Black Duck*, decoy, Anthony Elmer Crowell (1862–1951), East Harwich, Massachusetts, c. 1920, carved and painted wood (see page 38).

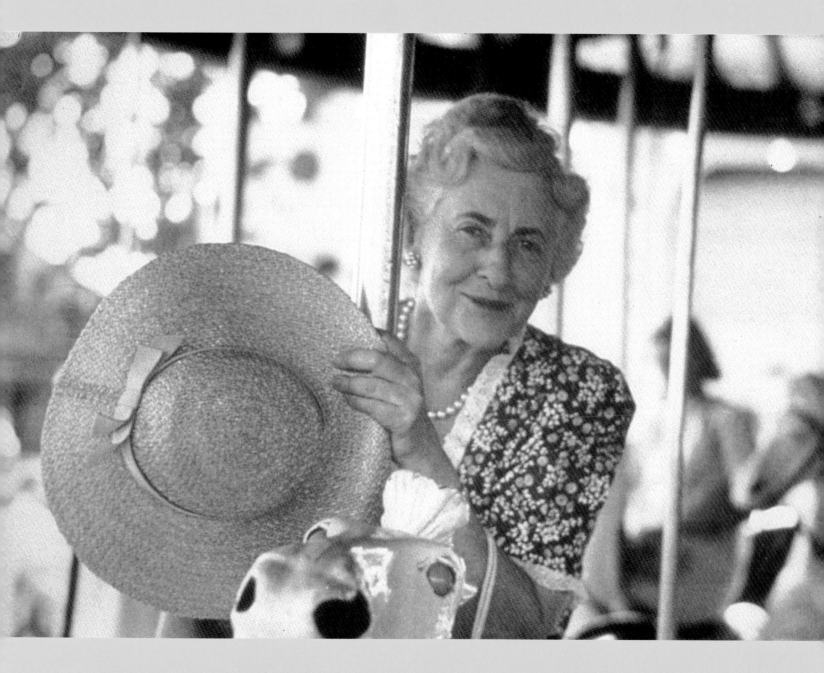

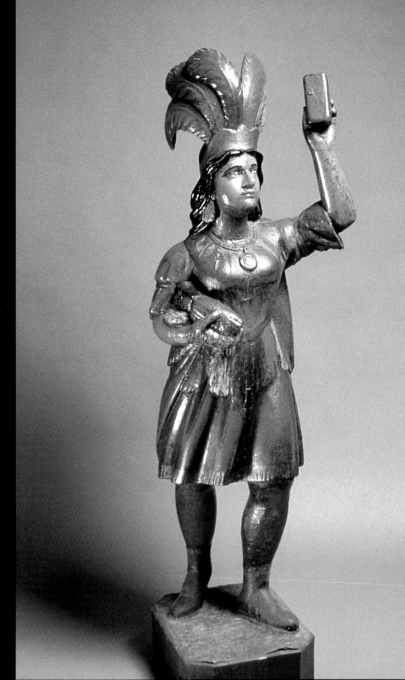

Electra's first acquisition of folk art sculpture: a nineteenth-century carved and painted wooden Indian by an unknown maker.

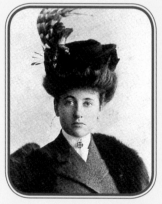

"ELECTRA, my dear, what have you done?"

Electra's mother was *not* pleased.

Electra smiled and replied, "I bought a work of art."

A wooden Indian was the object of her mother's dismay. It had been standing in front of a cigar store to advertise the tobacco sold inside. Electra noticed the rustic carving while driving through the Connecticut countryside one day in 1908 when she was just nineteen years old.

Electra Havemeyer Webb at age nineteen, c. 1908.

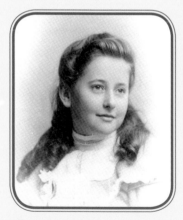

Electra at age ten, c. 1898.

"She spoke to me. I just had to have her," explained Electra.

The shocking purchase made no sense. At least not to Electra's mother. After all, Electra had grown up in a mansion on New York City's elegant Fifth Avenue. Its interior was created by Louis Comfort Tiffany, one of America's most famous designers. The home was, itself, a work of art. It also housed treasures from Europe and the Orient collected

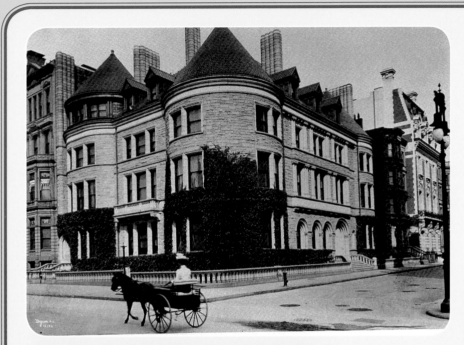

Electra's childhood home, the Havemeyer mansion on Fifth Avenue at 66th Street in New York City, c.1901. Its interior was created by Louis Comfort Tiffany, one of America's most famous designers.

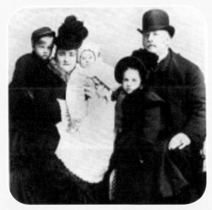

Louisine and Henry O. Havemeyer with their three children in 1888. Electra is the baby.

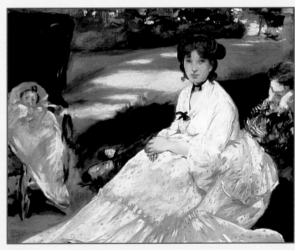

Edouard Manet (1832–1883), Au Jardin, 1870, oil on canvas. Electra's parents were among the first collectors of Impressionist paintings by artists such as Manet.

by her wealthy parents, Henry O. and Louisine Havemeyer. Priceless paintings, many of them by French Impressionists, were displayed along two second-floor balconies connected by a "flying staircase." Crystal fringes tinkled under the main landing as Electra ran across. The family had traveled with Electra to Europe, visiting museums and famous sites throughout the world.

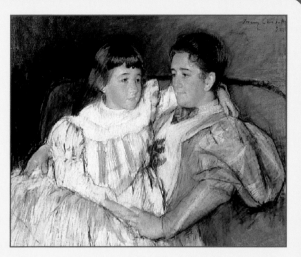

Mary Cassatt (1844–1926), Portrait of Mrs. Havemeyer and Her Daughter Electra, 1895, pastel. Electra was seven years old in this portrait.

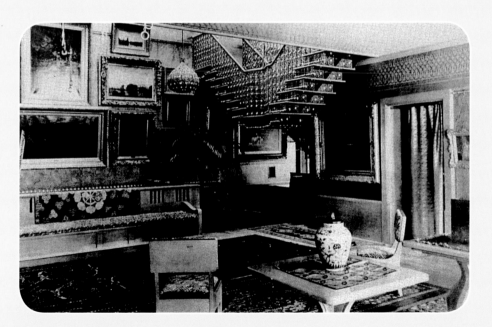

Interior of the Havemeyer mansion showing the "flying staircase." It connected two second-floor balconies that showcased spectacular paintings from the family's collection.

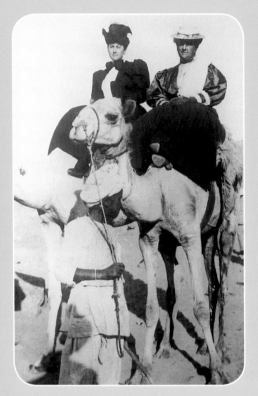

Electra and Louisine riding camels during a trip to Egypt in 1905.

Why on earth would Electra want to buy a wooden Indian?

Her father had recently died. Electra inherited a small fortune, and she had a mind of her own.

"I wanted to collect something that nobody else was collecting," she explained.

Besides, Henry O. always had told her that "it takes nerve as well as taste to be a *real* collector."

But for a while, Electra had to focus on other activities. In 1910, she married James Watson Webb, a handsome and

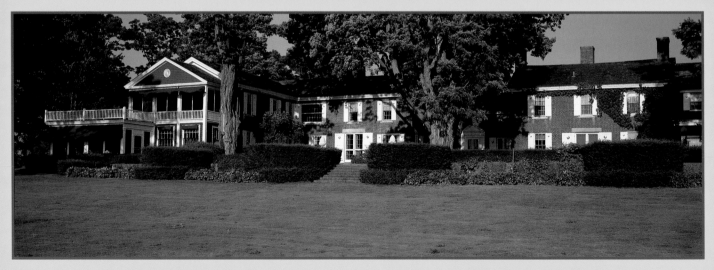

The Brick House, Electra's home in Shelburne, Vermont.

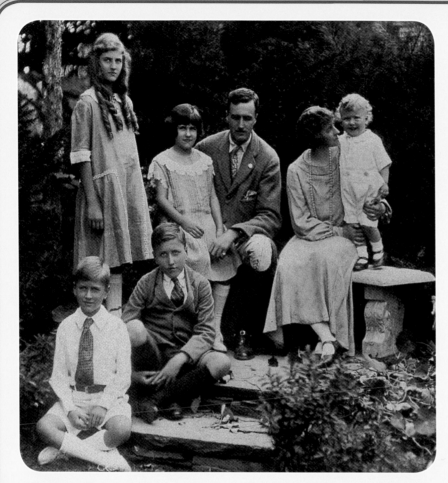

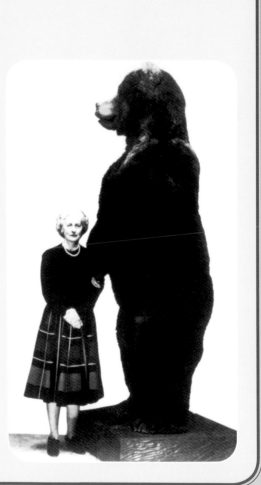

RIGHT: *Electra and the brown bear she shot on a hunting expedition in Alaska c. 1939. During one such excursion with her husband, Electra received a letter from one of their children, who begged her, "If you are given Mount McKinley and accept it, please don't try to move it to the Museum." Electra later reflected, "I doubt it would have been much more of a task than moving the Ticonderoga."*

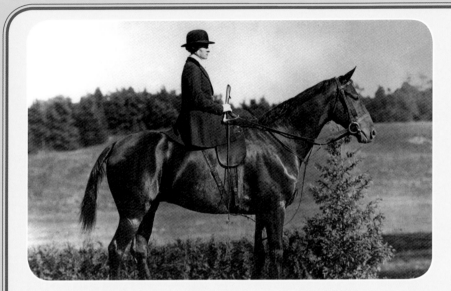

Electra spent many happy hours riding sidesaddle throughout Vermont, discovering lovely old houses, barns, and buildings. She might have been starting one such outing in this photo, taken about 1920.

RIGHT: *Dressed for entertaining at her Park Avenue apartment, c. 1934. Electra felt comfortable in a wide variety of settings, including elegant homes in New York City, the rural countryside of New England, a hunting camp in the Canadian Rockies, and Buckingham Palace, where she had dined with the Queen of England.*

wealthy heir to a railroad fortune. Over the next dozen years, the couple had two daughters and three sons. They lived in a big house on the property in rural Vermont where Watson had grown up, and also in the cities where he worked.

Electra loved horseback riding, was a great sportswoman and was not afraid to take part in activities that were unconventional for a well-bred lady of her time. She may have been small compared to her husband, but she hunted bears and caribou with him and often was the only woman on expeditions in Alaska and the Canadian Rockies. Back at home, she volunteered to

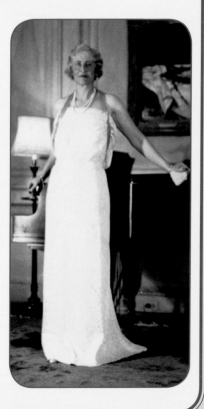

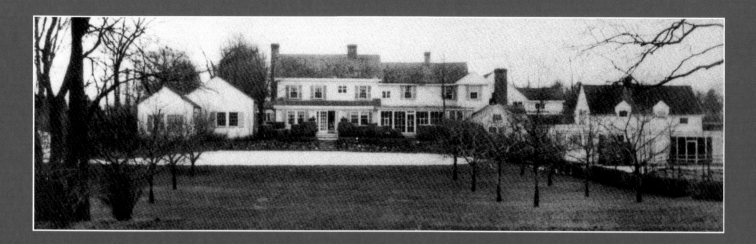

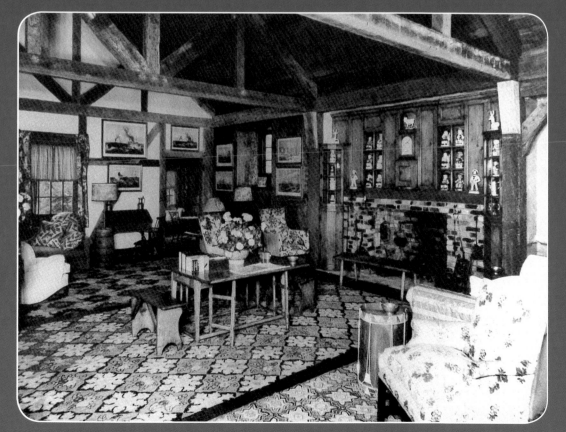

*The Webb house,
Westbury, Long Island
c. 1940, and the living
room, at left c. 1935.*

drive an ambulance in New York City during the first World War. And all the while, she ran her busy, growing households.

Eleven years after they wed, Electra and Watson bought a house on Long Island, near New York City. And that, as she would later tell it, was when she decided to collect in earnest. She owned a big, empty house, and she decided to fill it up with the things she loved.

Electra collected.

What did she collect?

"I chose the early, *crude* American," she said. "I selected this because I loved it – I was not influenced by anyone."

Her passion was for objects made by talented American craftspeople: wallpaper, rugs, quilts, and furniture that decorated

LEFT: Vermonter Delphia Haskins (1816–1892) or, perhaps, her daughter Ada made this "crazy quilt" in the 1870s and Electra purchased it for the Museum. Electra loved the colors and patterns of quilts. They provided warmth and an opportunity for a frugal homemaker to express herself artistically while sensibly using up old scraps of fabric.

The device pictured below is a whirligig carved in the late nineteenth century by an unknown maker. A whirligig is a three-dimensional figure often made with arms or paddles that spin in the wind and indicate wind direction (much like a weathervane) and wind speed. Whirligigs have their practical side, but mostly they are fun to watch. Spinning Woman was probably used as a trade sign for a yarn shop. Her spinning wheel would turn madly in a stiff breeze.

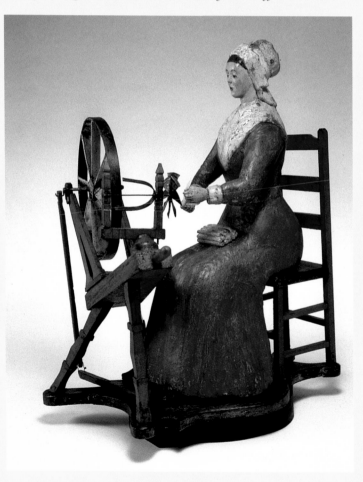

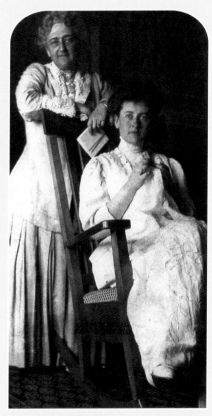

Louisine and Electra, c. 1908.

homes. Everyday kitchen utensils, working farm equipment, tools. Electra's eye elevated these objects from the ordinary, and could see the art within them.

But still, Electra's mother did not approve.

"How *can* you, Electra? You who have been brought up with fine European art live with such worthless trash?" she wondered and sometimes said out loud.

But Electra went on collecting. Weathervanes and whirligigs. Tinware and trade signs. Hat boxes and bread baskets and more, much more. Anything that spoke to her and, she hoped, would someday speak to others.

———◦◦◦———

Her mother called it "kitchen furniture." Commenting on the ships that covered Electra's dining room wallpaper, she said, "If you don't mind, I would like to sit with my back to that wallpaper. Those boats bobbing along the sea make me quite sick!" They were very different from the mosaics of glittering Tiffany glass that decorated the walls in the Havemeyer mansion of Electra's childhood. But Electra was quick to defend herself. "It must be pretty nice paper if it's that realistic!" And she continued collecting.

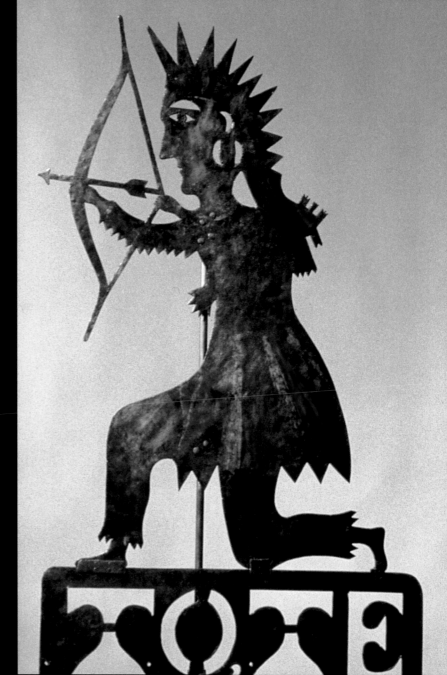

The word at the bottom of this weathervane (pronounced "toh-tay") stands for "Totem of the Eagles," a secret fraternal organization. Its nineteenth-century maker is unknown. Weathervanes were an important part of the early American skyline because people's lives were so closely connected with the weather. The success of a farmer's crop might depend on his ability to predict the approach of rain or a storm. Knowing wind direction could be a matter of life or death for a sailor. A weathervane mounted in a high place, with its movable pointer, showed the way the wind was blowing.

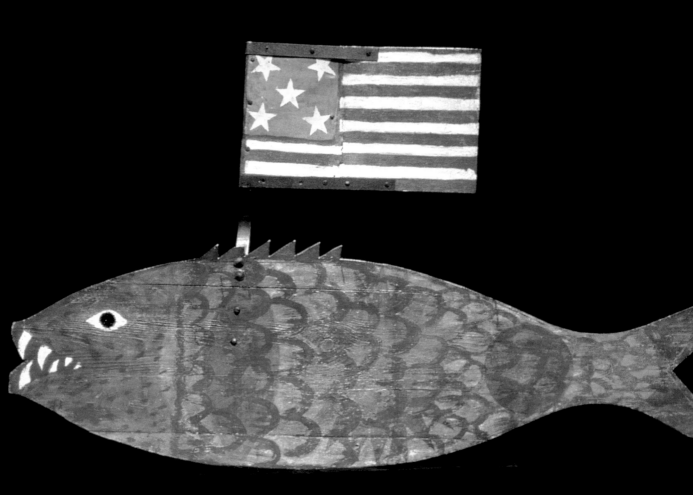

This fish with a flag, made of painted wood and sheet iron, is probably part of a trade sign that was used for an inn or tavern in the mid-nineteenth century. Its maker is unknown.

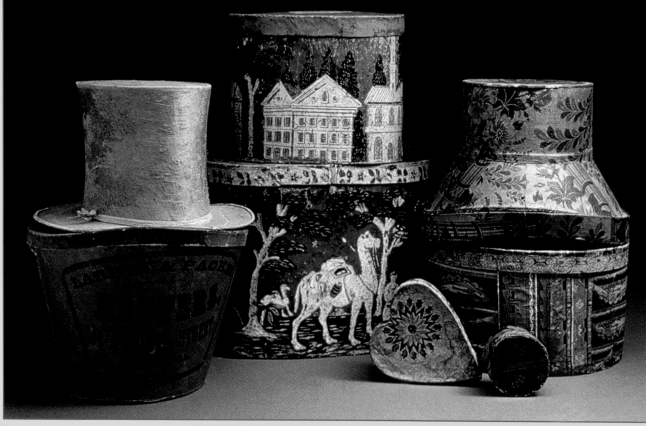

A collection of hatboxes. Folk art can be practical, like one of these hatboxes, which might have been checked in as luggage on America's new steamships and locomotives.

"I loved my folk art just as much as Mother loved her examples of European painting," she would say if challenged.

Soon, both her Vermont and New York homes were full up, and as Electra ran out of room, cherished items ended up on her indoor tennis court in Long Island. Family members joked that a set of tennis could be dangerous. You might easily trip over folk sculpture while playing. Her children would say, when asked where she was, "Oh, Mother's over in the tennis court playing with her junk!"

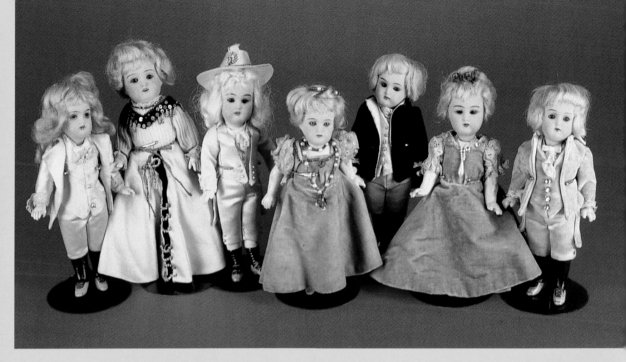

Dolls of bisque, cloth, and hair, c. 1898. Just before the nineteenth century became the twentieth – when Electra was about ten years old – her grandmother dressed a group of dolls in satin and pearls. She gave them to Electra. From that moment on, Electra collected dolls. When a birthday or Christmas came, she would ask for another one. "I loved those dolls, I looked at those dolls, but I never played with those dolls." She was afraid she might break them. "I just wanted to own them and as many more dolls as I could." Years later, Electra went into her attic and found that first collection of dolls. It is now in the company of hundreds of others at Shelburne Museum.

Years passed. Electra's five children grew up and moved out of their overstuffed house into homes of their own. In 1946, Electra and her husband retired to their country estate in Vermont, on the shores of Lake Champlain.

But what would be the fate of the treasures Electra had collected over the years and that she had grown to love so dearly?

The answer came as her husband's family had to decide what to do with the countless carriages, sleighs, and wagons *his* parents had owned. Electra offered a suggestion. Would they consider giving the vehicles to her if she bought a little piece of property where they could be shown and seen by others? The family thought that displaying the carriages would be wonderful.

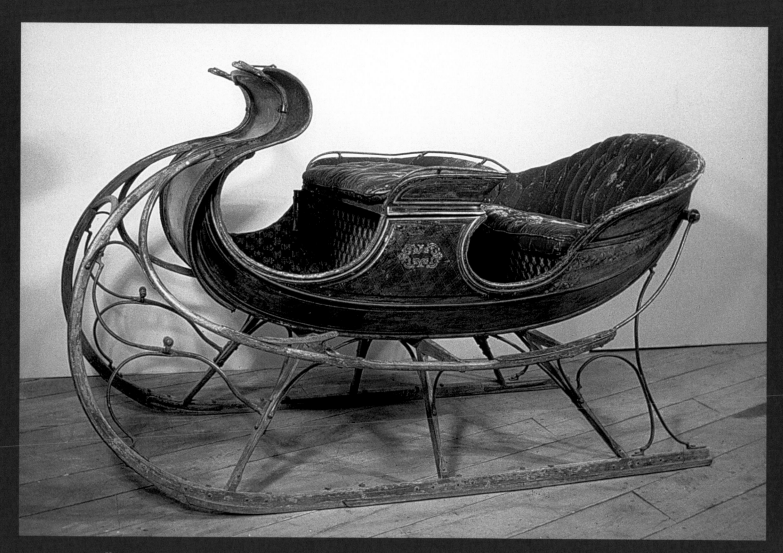

An Albany (or swell-bodied) sleigh, attributed to James Gould, c. 1870. In the late nineteenth and early twentieth centuries, a wealthy businessman like Electra's father-in-law would have owned a different vehicle for each of his transportation needs, but horse-drawn vehicles became available to others besides the very wealthy during the 1800s. An elegant coach could cost more than $400 in 1900, but you could buy a simple one from a mail order catalogue for $24.95. In snow country like Vermont, Thanksgiving was the traditional day to switch from wheeled buggies to sleighs and to bring out fur robes, foot warmers, and sleigh bells.

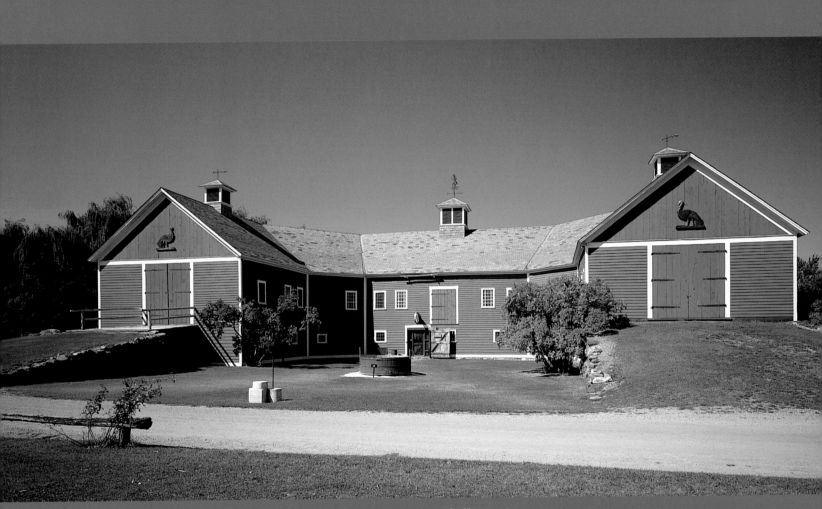

The Horseshoe Barn as it appears at Shelburne Museum.

"You go ahead and have your hobby and do what you want," they said, pleased at having found a place for their collection of vehicles.

"Now that was the spark that lit the fire. I had my opening," Electra remembered.

And that was the start of Shelburne Museum.

Electra was thorough, and she had thought everything through. She saw her chance and was determined to exhibit her own treasures along with the carriages.

She bought a small piece of property with a little house on it not far from her Vermont home. This became the gallery for Electra's collection of glass, silver, ceramics, and dolls.

But the carriages and cars needed more space. Electra thought a big barn would do nicely, but it had to be just right. She scoured the whole state of Vermont until she found a large barn shaped like a horseshoe that she loved and decided to copy for the Museum. She then journeyed across Vermont for another six months searching for abandoned barns and gristmills from which she could salvage beams and shingles. She looked at one hundred and fifty structures and found twelve barns and two gristmills with materials that were suitable for building the Museum's Horseshoe Barn, the new home for the vehicles.

But Electra needed even more space to hold her collections.

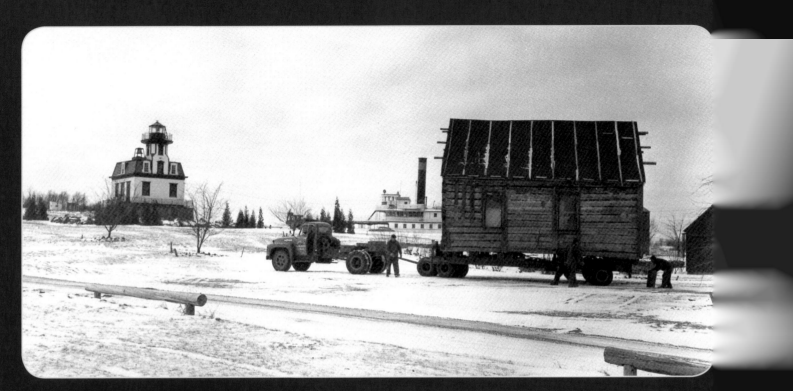

Sawyer's Cabin, a one-room house built in 1800, was purchased by the Museum in 1955 and moved there in one piece. The Lighthouse is in the background.

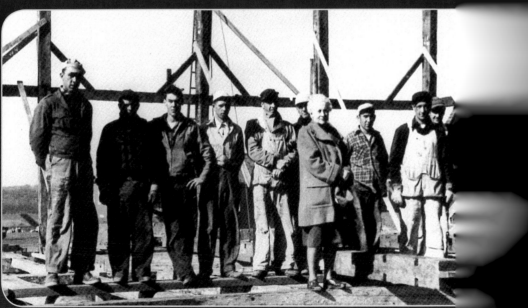

Electra visiting the work crew at the Stagecoach Inn, 1949.

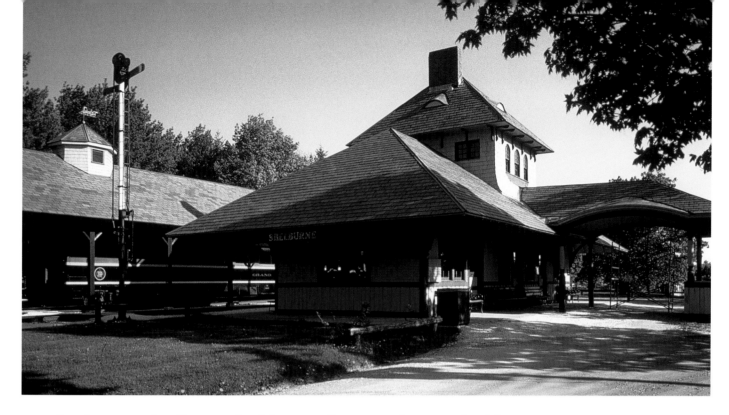

So she started collecting *buildings* and moving them to the Museum grounds. Some were transported in one piece. Others were taken apart, with every piece carefully numbered, then rebuilt on the property.

Electra believed these structures were folk art, too. Instead of being small pieces of folk art, they were big examples of homegrown American architecture and ingenuity. They were simply an extension of her collecting, and they all had important stories to tell – about the people who built them, lived in them, and used them.

She collected a one-room schoolhouse, an inn, several houses, a jail, a lighthouse, a sawmill, a blacksmith shop, and a brick meeting-

The Shelburne Railroad Station, built in 1890 by Electra's father-in-law, Dr. William Seward Webb, while he was president of the Rutland Railroad. Passenger service through Shelburne was discontinued in the early 1950s. Dr. Webb's family gave the station to the Museum, which moved it there in 1959.

[25

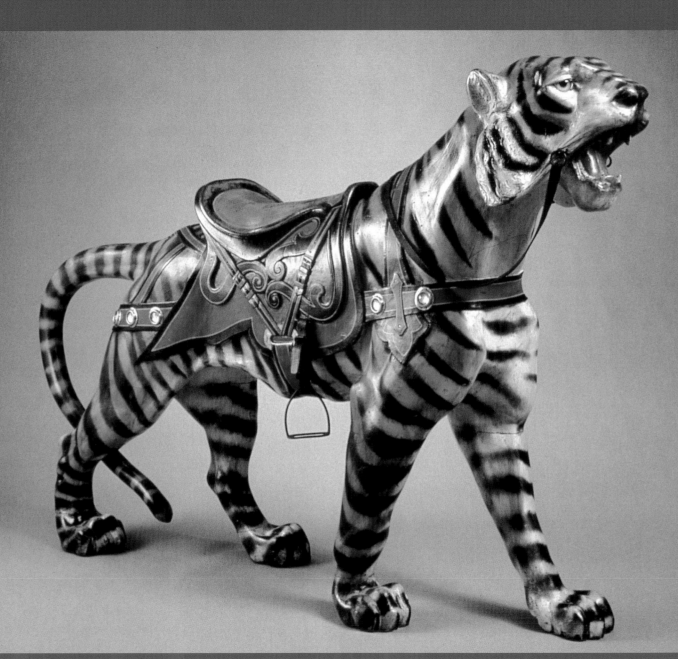

Carousel figure, carved around 1902 by Daniel Muller (1872– 1952), for the Gustav Dentzel Carousel Company (1867-1928) in Philadelphia, Pennsylvania. This tiger is one of forty-four animals in the Museum's collection that form a complete set made by Dentzel's company.

house. She also collected a railroad station, a covered bridge, a carousel, and a 900-ton steamboat.

In explaining all this Electra observed, "Collecting is a mania. Once you start, you can't stop."

The covered bridge she bought was destined for destruction. Built in 1845 in Cambridge, Vermont, it could no longer handle the demands of modern traffic. Electra came to the rescue. When asked what she

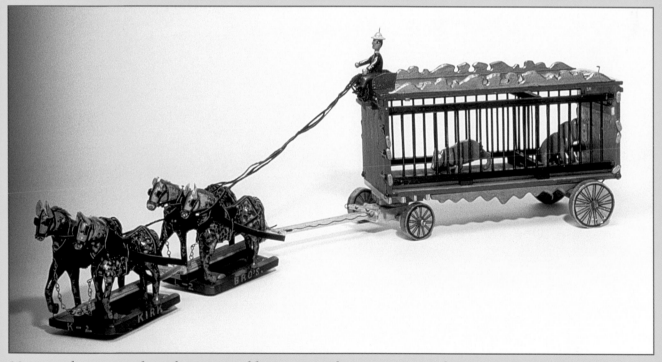

Miniature lion wagon from the Roy Arnold Circus Parade, c. 1925–1955. This wagon was part of a diminutive traveling circus caravan, scaled at one inch to the foot. Running five-hundred feet through the Museum's Circus Building, it was carved and assembled by Roy Arnold of Vermont and four other skilled craftsmen over the course of thirty years.

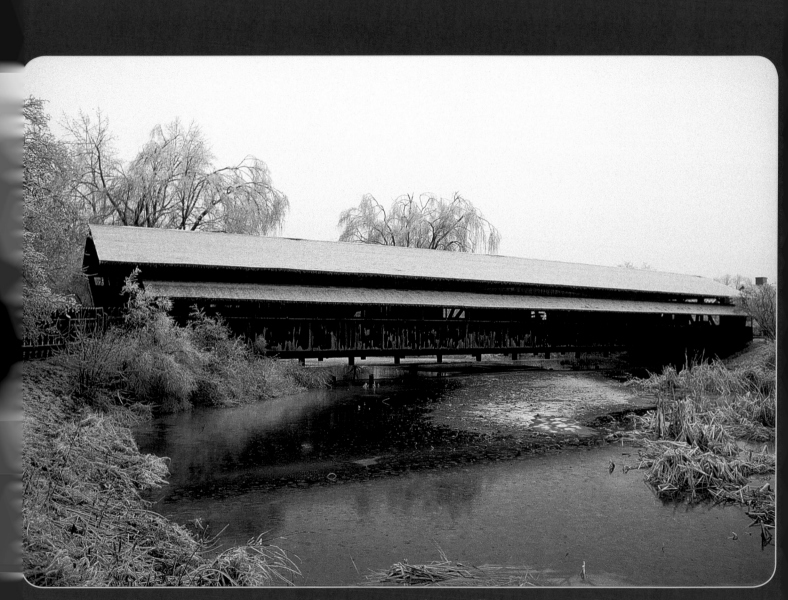

The covered bridge in winter. Built in 1845 to span the Lamoille River in Cambridge, Vermont, the bridge was taken apart, moved to the Museum, and reassembled there in 1949.

would do with it, she replied honestly "I really don't know! Let's just get it first and then we'll figure out what to do with it!" Each beam was numbered, the bridge was taken apart, and reassembled at the Museum. You can still see the numbers.

The Colchester Reef Lighthouse had been out of service for twenty years, replaced by an electric beacon. Built in 1871, it had provided a home and work for eleven lighthouse keepers and their families. Now, in 1952, it was filled with cobwebs and falling apart. When Electra learned of its sad fate, she took a little boat to the middle of Lake Champlain to see it for herself. She climbed up the reef, opened the door, pushed through two decades of spider webs, peeked in all the rooms, marched to the top and said, "I have *got* to have this lighthouse!" But taking it apart, ferrying the pieces to shore, and rebuilding it at the Museum was a daunting and dangerous job. The Museum's insurance company refused to cover the risk. Electra's team of dedicated workers saw the problem and wanted to help Electra get her lighthouse, so they devised a plan.

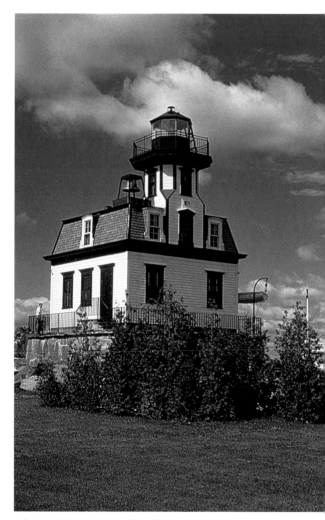

The Colchester Reef Lighthouse at Shelburne Museum. It was painstakingly taken apart where it stood on a reef in Lake Champlain and ferried, piece by piece, to shore.

They quit their jobs so that the Museum would not be responsible, and told Electra, "We'll move the Lighthouse on our own and give it to the Museum." They did, and when the Lighthouse was safe at its new home, they asked for their old jobs. Electra was only too happy to welcome back her loyal crew.

The steamboat *Ticonderoga* is 220 feet long, 59 feet wide, and weighs more than 900 tons. During the first half of the twentieth century, it carried passengers and freight across Lake Champlain but by 1950, the majestic *Ti* was considered outdated. Electra could not bear to see her turned into junk. The day before the *Ti* was headed to the scrapheap, Electra decided to buy her for the Museum.

She feared the extravagant and unusual purchase would alarm her husband but by then, he was used to Electra's collecting. When she confessed what she had done, he simply remarked, "Well, that's not so bad. I think a lot of other stuff you bought is much worse!"

For three summers, the *Ti* continued her life as "a living exhibit on the Lake." But she was hard to maintain and finding qualified crews to run the *Ti*'s popular passenger excursions was difficult and expensive. The Museum's advisors debated the sidewheeler's fate, but Electra made the final decision: she'd move the *Ti* to the Museum.

Electra recalled, "I heard my father's voice saying, 'If you feel

something is right, have the courage of your conviction. Nothing ventured, nothing gained.'"

Months of preparation preceded the monumental move that finally began in November of 1954. A huge basin was dug at the edge of Shelburne Bay, where the *Ti* patiently awaited her journey. Two sets of railroad tracks were laid in the bottom. The basin was filled with water and a tugboat pushed the *Ti* into it. The water then was pumped out

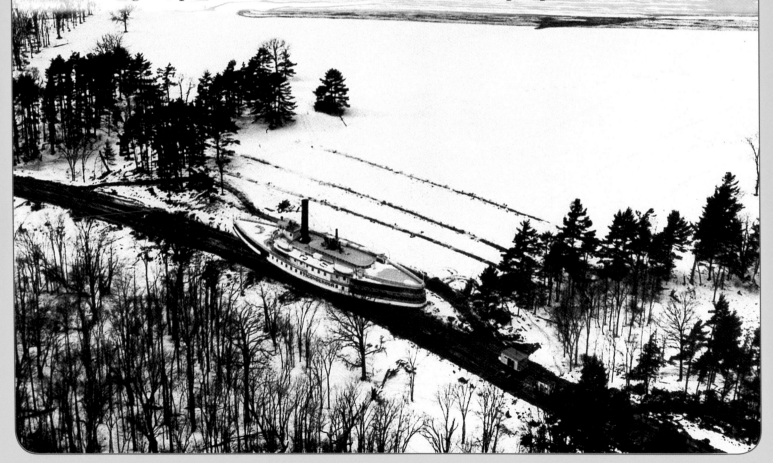

of the basin and the *Ti* settled into a specially-built cradle that nestled her on the tracks.

And so, on January 31, 1955, the vessel was launched on her remarkable two-mile overland trip. The *Ti*'s hull had been welded to the cradle to keep her from overturning in high winds. The lower half of her huge paddlewheels, two stories tall, were removed. Power lines and telephone wires were rerouted. The ground over which the *Ti* would pass was leveled and cleared. Temperatures had to drop to freezing or below, as only frozen-solid ground could support the ship's immense weight. But the bitter cold also froze the grease on the cradle's freight car wheels. Cans of burning oil were hung near the wheels to soften the grease and enable the wheels to turn smoothly. Steel cables attached the *Ti* to winches on trucks alongside and in front of the boat. The winches tugged the *Ti* inch by inch so that it crept forward between one-hundred-fifty and two-hundred-fifty feet each day.

But in early March, weather threatened catastrophe. The *Ti* had just crossed a frozen brook and swamp when steadily rising temperatures began to thaw the ice. Within a day, the ice had melted, the frozen swamp was a lake, and the brook was overflowing. The ground underneath the rails, which were perilously close to the flooded brook, began to wash away. Work crews scrambled to keep the *Ti* from toppling over. In end, they managed to channel the approaching floodwaters across the road and away from the boat, narrowly saving the ship from capsizing in mud. After a harrowing sixty-five days, she finally arrived home at Shelburne Museum.

"It took a desperate toll not only financially, but on the nerves of all concerned,"

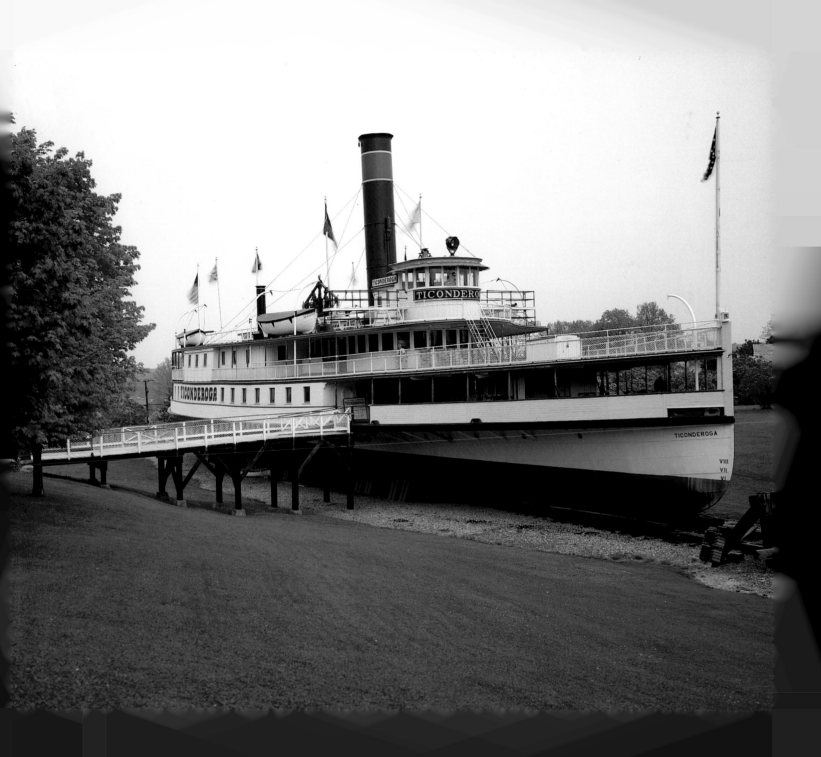

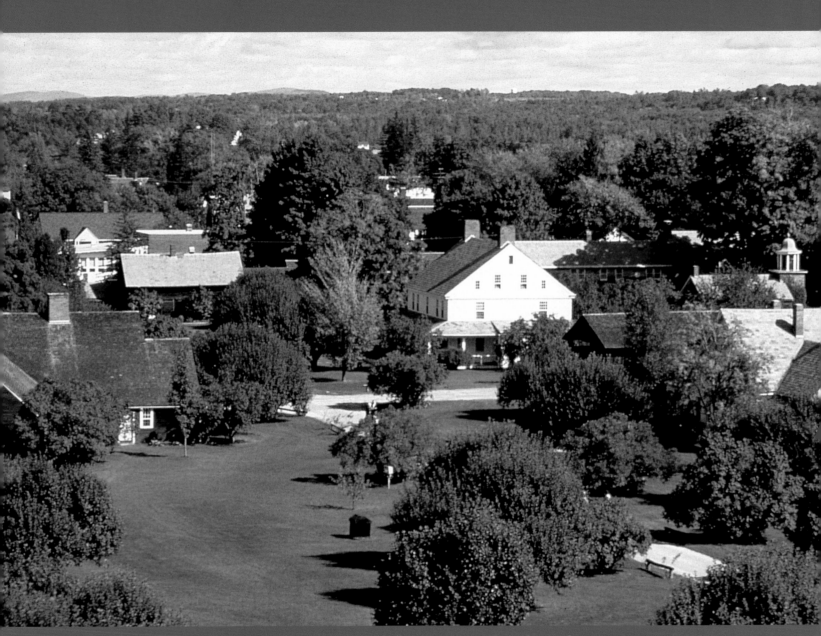

An aerial view of Shelburne Museum from the north.

Electra recalled. But it was worth it. "I think she's a queen."

When Electra first created the Museum, she wasn't sure what it would be like. "It was all up in my head," she said. But over time, she finally did figure out what she wanted the Museum to be. It would be a place where visitors could learn about American art and craftsmanship in a way that would be unique and fun. She wanted to show that beauty can be seen and found all around us, even in everyday and "ordinary" items that were intended to be practical rather than ornamental.

Above all, she wanted to share her belief that folk art is, indeed, *art*, made by craftsmen who had a strong desire to create something beautiful. It could take the form of a house or a hatbox, a stenciled pattern or a steamboat. It could be big, like a lighthouse, or small, like a dollhouse. You might know the name of the

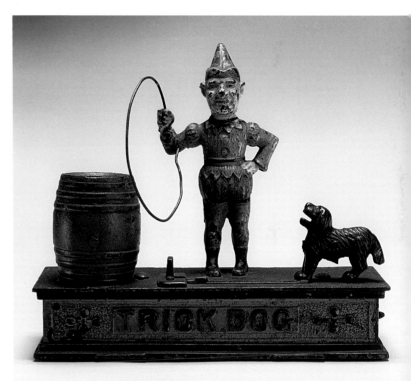

Trick Dog Jumps through Hoop. Mechanical bank. 1888. Place a coin in the dog's mouth and press the lever. The dog jumps through the hoop and drops the coin in the barrel.

Female Seminary Dollhouse. Electra loved collecting dolls and dollhouses. This one might have been made in France around 1870. It is inhabited by a tiny teacher and pupils from Electra's collection of miniatures.

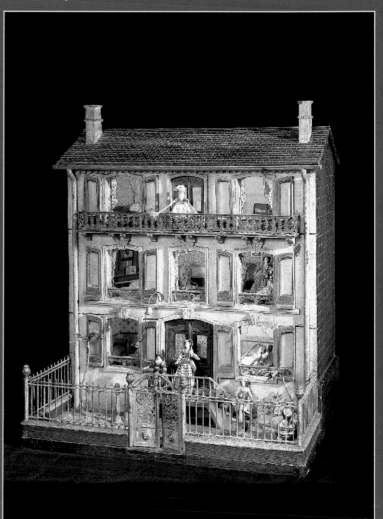

In the 1700s and 1800s, furniture in America was often painted to hide the fact that it was made from inexpensive wood. This chest was decorated to look like black lacquered furniture from Asia that was popular in homes of the wealthy at the time. It was often called a "Harvard chest" because the red buildings were mistaken by some viewers for structures at Harvard College.

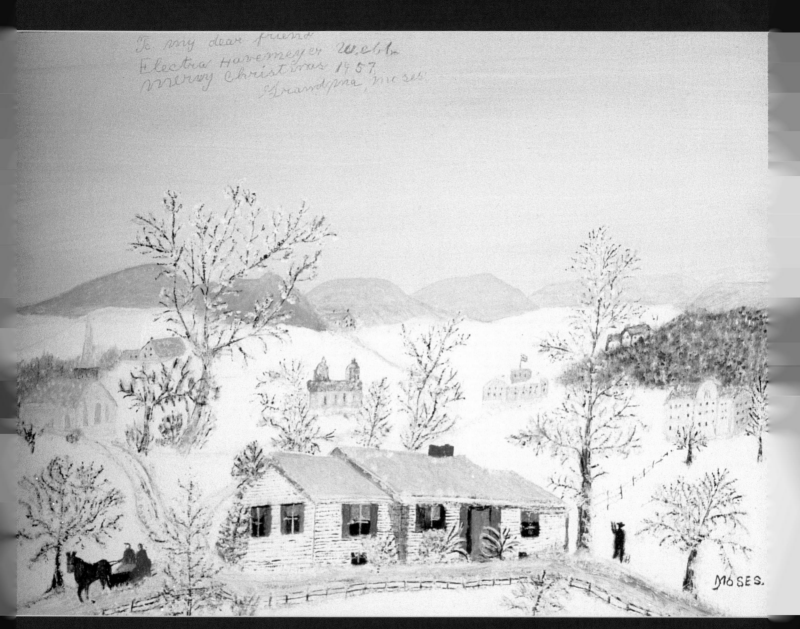

Anna Mary Robertson (Grandma) Moses (1860–1961), Old Home, *1957, oil on masonite. Grandma Moses began painting in the 1930s when she was in her seventies and eventually became one of America's most famous folk artists. Grandma Moses, as she was known, became friends with Electra and gave this painting to her as a gift.*

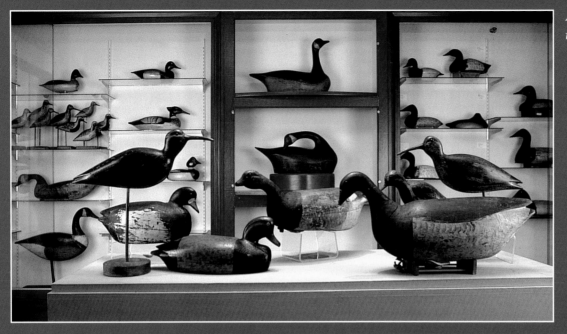

A display of decoys in
the Dorset House.

Black Duck, decoy carved about 1920 by
Anthony Elmer Crowell (1862–1951),
East Harwich, Massachusetts. Decoys
were invented by Native Americans, who
observed that wildfowl could be lured close
to a concealed hunter and his weapons by
simple forms that roughly resembled the
birds. By the mid-1800s, craftsmen began
making carvings that more closely appeared
to be real birds, with details like carved
and painted feathers. A hunter as a boy
who began making decoys at the age of ten,
with no training other than a few drawing
classes, Anthony Elmer Crowell was one of
America's most gifted decoy carvers. The
delicate feathers, lifted wings, and realistic
painting of his finest decoys, such as this
black duck, make them look almost alive.

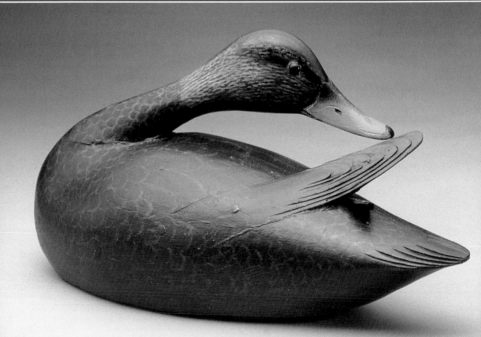

person who created it – or you might not, but it was still art.

To Electra, folk art was something that "welled up from the hearts and hands of the people." They did not go to art school. They were farmers, carpenters, schoolchildren, and blacksmiths – ordinary people who did something extraordinary by creating objects whose beauty would last long after their purposes had been served. Electra's passion for collecting these pieces of America was transformed into Shelburne Museum. Today, it offers one of the finest displays of American folk art, crafts, and architecture in the world. And although Electra died in 1960, Shelburne Museum continues to carry on its mission and to share her greatest dream. "I wanted to return to the country the objects that had given me so much pleasure in the hope others might enjoy them as much as I enjoyed collecting them."

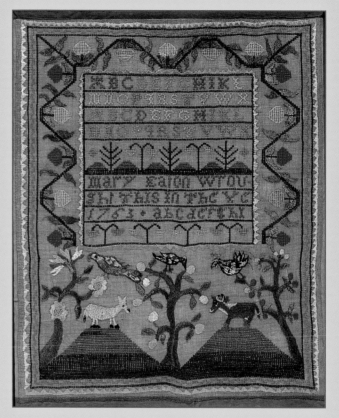

Sampler by Mary Eaton, 1763, silk-embroidered linen. For girls, skill with the needle was a mark of good breeding. They practiced their stitches on fancy samplers proudly displayed by parents in their homes.

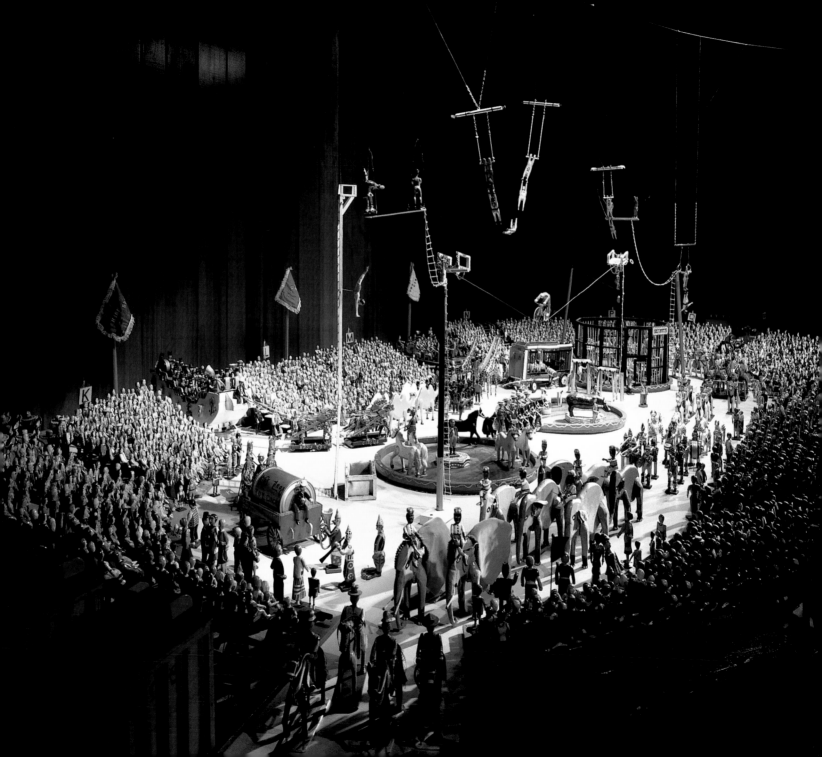

Electra's Attic

WHEN I WAS A CHILD, visiting Shelburne Museum was like peering into my great-grandmother's attic. I always discovered new surprises and unexpected treasures that were part of our family history. Each summer, we left New York City for Vermont, and we spent nearly every rainy day – and plenty of sunny ones – at the Museum, poking around among wooden duck decoys, climbing the narrow lighthouse stairs, and admiring the view of Lake Champlain from the deck of the *Ticonderoga*. I could sit on the sidesaddles in the Horseshoe Barn and imagine riding to the hounds with my great-grandmother, Electra Havemeyer Webb; I could reenact the *Wild, Wild West* television show aboard my great-great-grandfather's private railway car; I could even crawl into the bear's cave outside the Beach Gallery, imagining what it would be like to have stood in Electra's boots as she faced the enormous Kodiak bears she shot on expeditions to Alaska. I shuddered before the tribe of cigar-store Indians that stood, tomahawks cocked, in the entrance to the Stage Coach Inn. Stealing swiftly past them and escaping up the stairs, I was thrilled by an enormous eagle whose twelve-foot wingspan nearly touched the ceiling. I marveled at the spareness of the schoolhouse and the spindly newspaper dunce hat we took turns wearing. As I grew older, the self-taught painter who created Magic Glasses (shown next to the real glass) fascinated me. During more recent visits with my two young sons, I have been able to see through their eyes my early experiences

OPPOSITE: *The "Kirk Bros. Circus," a four-thousand-piece miniature circus carved over a period of more than forty years by Edgar Decker Kirk (1891–1956), Harrisburg, Pennsylvania. Kirk was a brakeman for the Pennsylvania Railroad and created each piece of the circus from scrap lumber during his spare time. Folk art often was practical but could be purely fanciful, and Kirk would let neighborhood children play with his miniature acrobats, animals, performers, and spectators.* DONORS: RICHARD AND JOY KANTER

Electra Havemeyer Webb with three grandchildren sitting on a trade sign for a Vermont furniture company, c. 1958.

of watching red-hot iron magically hammered into small horseshoes we superstitiously pointed ends up so the luck would not pour out.

My great-grandmother died before I was born, but I was very close to my grandmother, her eldest child, also named Electra. I have always felt a close affinity for my great-grandmother. When my husband and I were married, our reception was held at her home. I was the first to wear both the wedding dress and veil she had worn in 1910, though my grandmother had worn the dress and my aunt and sister the veil.

Through my grandmother I learned all about art, Shelburne Museum, and the people who had worked with my great-grandmother to make her dreams of a museum in Vermont come true. My grandmother often repeated her mother's words that one should feel at home whether eating at a scrubbed pine table in the simplest farmhouse or being served by footmen at Buckingham Palace, where my great-grandmother had dined with the Queen. I witnessed this philosophy in action as my grandmother moved seamlessly between the grand apartment houses of New York and the narrow back roads of Vermont. During my youth, my grandmother and I would visit the Museum often and stop to speak with many of the people who had worked there during the early years. They had been farmers, Yankee-jacks-of-all-trades, known for their ability to tackle any task. Their eyes twinkled as they spoke about Electra Havemeyer Webb, recalling how they had built shadow boxes for her, how they had worked on the miniature models that she could move around to place buildings and exhibits, or even how they managed to drag the sidewheeler *Ticonderoga* two miles overland through the frozen fields of my grandparents' farm.

People often ask what it was like to grow up with paintings that are now at major art museums. To us, it seemed perfectly natural: we drank tea, set up the Parcheesi game with my grandparents, or tore open Christmas presents in their living rooms surrounded by all of these masterpieces that seemed like close friends. Art was part of the fabric of our everyday lives, so much so that our family felt a deep sense of duty to share it with the public at the Metropolitan Museum of Art in New York City, at Shelburne Museum in Vermont, and at several other institutions along the Eastern seaboard.

You can learn a great deal about people from their voices. Electra Havemeyer Webb had a distinctly old-world accent that charmed people from all walks of life. Every so often, I catch myself pronouncing words like turkey (TUUR-key), mayonnaise (my-own-AIZE), Degas (DAY-ga), museum (MEW-zim) in much the same way my grandmother echoed her mother, whose voice we knew from speeches she had recorded. Family members used to joke that the Havemeyers had developed an unusual Brooklyn accent thanks to all the time they spent visiting their sugar factory there. To many people, Electra, like her accent, defied classification.

Velocipede, maker unknown, early 1900s. This toy was modeled after a full-sized version of the early riding vehicle.

Electra loved to laugh and have fun, and my grandparents definitely shared her sense of humor. She made sure that everyone would be comfortable at Shelburne Museum by providing all sorts of collections within easy walking distance that included a carousel, a sidewheeler, and whimsical folk art. Her own upbringing had been very formal, judging by how we live today, and all the more so when her family went into mourning after the death of her father when she was only nineteen. Electra's exuberant reaction was to follow her heart. Her father had always said it "took nerve to be a collector," and that very same year she bought her first cigar-store Indian that she named Mary O'Connor after a beloved family housekeeper.

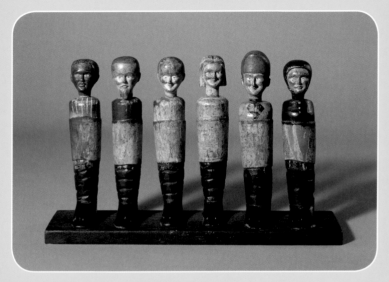

These six smiling nineteenth-century carved and painted wooden figures, the work of an unknown woodworker, were part of a popular indoor bowling game called "nine pins."

Her mother, Louisine also had many mottos, but one that Electra Havemeyer Webb and her son, Watson, often repeated was, "Laugh and the world laughs with you. Cry and you wet your shirt." Laughter and joy were welcome at Shelburne Museum, and Electra made sure that there were lots of attractions for children, including the lollipops she knew her grandchildren favored. Art was there to enjoy and to celebrate the charm and ingenuity of an earlier time, but, along the way through the acres of Vermont landscape, there were apples to be picked, horses and buggies for pretend drives, and hidden gardens to explore. During one Museum visit when our children were younger, we had a hard time pulling ourselves away from the pond tucked next to the Meeting House. The boys discovered a pod of bullfrogs among the reeds and insisted on meeting and greeting each one of them with deep thumps and grumps.

In her time, Electra was often criticized, even ridiculed, for her collection and her ambition to display it in old buildings she had rescued from destruction. When she described her hope to save her father-in-law's carriage collection by placing it inside an old barn, her financial advisors told her it would be far easier to build a Quonset hut – a cheap, industrial building with a curved tin roof. She was discouraged, but she never gave up. As her father liked to say – and as Electra often repeated – "It is not important whether you are knocked off, it is whether you get back in the saddle that matters." Instead of a Quonset hut, she scoured the Vermont countryside to find barns and a gristmill that would provide the old beams and planks to construct the Horseshoe Barn, and with that act of faith Shelburne Museum was born.

She loved simple objects, not fancy ones, pieces made by what she called "just plain folks" for their everyday pleasure and use. She had grown up in an imposing house on

Fifth Avenue, but her own homes were chock-full of cozy corners, nooks, and crannies brimming with her collections. They were like dollhouses built for adults. In Long Island and Vermont, she would add room after room for her English Toby jugs and Staffordshire pitchers, her hatbox collection, and her pewter. At the Brick House in Vermont, she would add a tiny stairway up to a low attic room filled with dolls where her grandchildren could hide away and play under the eaves. The Variety Unit and the Hat and Fragrance Buildings, with their inset shadow boxes and small collections carefully arranged around corners and up and down stairs, closely and deliberately resemble the homes she especially loved. Sometimes Electra Havemeyer Webb got so carried away with her passion for arranging objects that my grandmother would return from an afternoon at the beach in Shelburne and find the living room furniture completely rearranged by her mother!

When we visited the Museum as children, we used to drive slowly through the original entrance, a dark covered bridge, at nearly the pace dictated on the wall, "Horses at a Walk." We'd giggle as the ticket taker poked his head out of a small building we knew used to be an outhouse. We'd pull up amid a tiny cluster of buildings with the Meeting House standing proudly before us. Although it was summer, the marvelous, storybook setting always reminded me of the miniature villages covered in snow that often appeared in shop windows at Christmas.

As in the familiar song, "Over the river and through the woods. . . ," we couldn't wait to visit our great-grandmother's many houses, eagerly anticipating a glimpse of our favorite objects and the possibility of making new discoveries. I hope all of you who read this book about Electra will have a chance to visit her museum and have as much fun as we did peering into her attics and seeing all her treasures as they are unpacked before you.

ELLIOT BOSTWICK DAVIS
Brookline, Massachusetts

DEGAS: Born in Paris, Hilaire Germain Edgar Degas (1834–1917) became one of the earliest painters of the Impressionist movement. He is known for asymmetrical arrangements of figures and empty space in his paintings. He was fascinated by movement and painted many pictures of ballet dancers and racehorses. In 1875, Electra's mother was the first American to purchase a work by Degas.

IMPRESSIONISM: A theory and school of painting whose goal was to capture a momentary glimpse of a subject, emphasizing the changing effects of light and color. It was a bold departure from the more realistic works of art that were produced before the 1860s. Electra's parents were among the first Americans to collect and appreciate the Impressionists.

MANET: Also born in Paris, Edouard Manet (1832–1883) was one of the founders of the Impressionist movement. His training at the Ecole des Beaux Arts was traditional, but he abandoned it to experiment with new techniques in pattern, form, and color.

MONET: Claude Monet (1840–1926) was another notable Paris-born Impressionist painter and founder of the movement. He studied the interplay of color and light and sometimes painted a series of canvases that studied changing atmospheric effects on a recurring subject (such as a haystack or a cathedral).

MOSAIC: A picture or design made by placing into mortar small pieces of material such as colored stone, glass, or tile.

REMBRANDT: A master portrait painter, Rembrandt van Rijn (1606–1669) was born in the Netherlands. Electra's father collected many fine paintings by Rembrandt and other Dutch and Flemish painters known as Old Masters.

TIFFANY: Among the most famous American designers of decorative objects and jewelry in the late nineteenth and early twentieth centuries, Louis Comfort Tiffany (1848–1933) became known for his work with stained glass and mosaics, such as those in Electra's childhood home.

TINWARE: Objects made of tin, either decorated or plain. They were often household items such as candleholders or kitchenware.

TRADE SIGN: A handmade sign for a shop, often painted and carved with symbols of the shop's goods or services. A wooden Indian advertised a store that sold tobacco, for example, or a carving of a giant pair of glasses would indicate an optician's shop.

The photographs in any of the following books can be enjoyed by all ages. Experienced readers can help newcomers appreciate the unique insights of the writing.

Bishop, Robert and Jacqueline Atkins. *Folk Art in American Life*. New York: Viking Studio Books, 1995. A broad sampling of folk art from the seventeenth through the twentieth centuries.

Brant, Sandra and Elissa Cullman. *Small Folk: A Celebration of Childhood in America*. New York: E.P. Dutton in association with the Museum of American Folk Art, New York, 1980. An exploration of the relationship between children and folk art that examines children as creators, users, and subjects of the form.

Hewes, Lauren B. and Celia Y. Oliver. *To Collect in Earnest: The Life and Work of Electra Havemeyer Webb*. Shelburne, Vermont: Shelburne Museum, Inc., 1997. A biography of Electra Havemeyer Webb.

Ketchum, William C., Jr. *American Folk Art*. New York: Todtri Productions Limited, 1995. An overview of American folk art.

Lipman, Jean, Robert Bishop, Elizabeth V. Warren, Sharon L. Eisenstat. *Five-Star Folk Art: One Hundred American Masterpieces*. New York: Harry N. Abrams, Inc., Published in association with the Museum of American Folk Art, New York, 1990. Art experts select and discuss one hundred of the finest examples of American folk art (including objects from Shelburne Museum) and discuss the concept of "quality."

Lipman, Jean, Elizabeth V. Warren, Robert Bishop. *Young America: A Folk-Art History*. New York: Hudson Hills Press in association with the Museum of American Folk Art, New York, 1986. A history of the United States between the American Revolution and the First World War as told through folk art and organized by activities of daily life.

Panchyk, Richard. *American Folk Art for Kids, with 21 Activities*. Chicago: Chicago Review Press, Inc., 2004. An overview of American folk art intertwined with arts and crafts activities for children.

Electra to the Rescue has been set in Caledonia, a type designed in 1939 by the famed American typographer and book designer William Addison Dwiggins. The product of Dwiggins's wide-ranging efforts to create a type in the lineage of the Scotch Romans of the early nineteenth century, Caledonia can claim a fair number of types among its ancestors. Yet such was Caledonia's success that its mixed heritage could not prevent it from taking its place among more thoroughbred types as one of the most popular book faces of the mid-twentieth century. The display type is Miller, a later interpretation of Scotch by Matthew Carter, with additions by Tobias Frere-Jones, Cyrus Highsmith, and Todd Hallock. In combination, the two families capture the liveliness and warmth of the types that inspired them, while avoiding the older types' unevenness of color and inconsistencies of form.

DESIGN AND COMPOSITION BY DEDE CUMMINGS &
CAROLYN KASPER, DCDESIGN / BRATTLEBORO, VERMONT

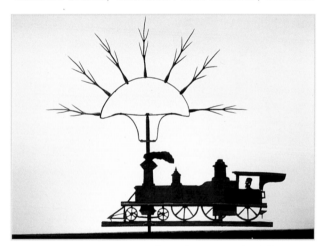

Locomotive, weather vane, maker unknown, made of sheet zinc, brass, and iron in the mid-19th century. It might have been used on a railroad station in Providence, Rhode Island. The iron sunburst was probably added later as a lightning rod.